HOW
to
BE
an
ARTIST

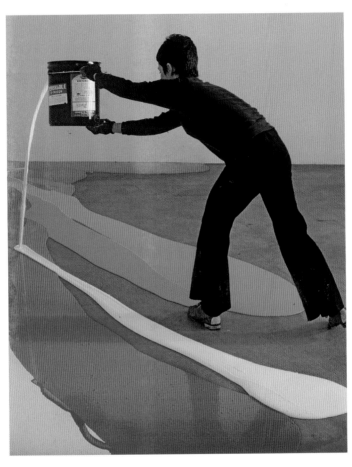

Lynda Benglis, Fling, Dribble, and Drip, *1970*

HOW

to

BE

an

ARTIST

———

JERRY SALTZ

RIVERHEAD BOOKS • NEW YORK

2020

RIVERHEAD BOOKS
An imprint of Penguin Random House LLC
penguinrandomhouse.com

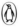

Copyright © 2020 by Jerry Saltz
Penguin supports copyright. Copyright fuels creativity,
encourages diverse voices, promotes free speech, and creates a
vibrant culture. Thank you for buying an authorized edition of this book
and for complying with copyright laws by not reproducing, scanning,
or distributing any part of it in any form without permission.
You are supporting writers and allowing Penguin to
continue to publish books for every reader.

Portions of this book originally appeared, in slightly
different form, in *New York* magazine.

Page 130 constitutes an extension of this copyright page.

Riverhead and the R colophon are registered trademarks
of Penguin Random House LLC.

Library of Congress Cataloging-in-Publication Data

Names: Saltz, Jerry, 1951– author.
Title: How to be an artist / Jerry Saltz.
Description: [First hardcover]. | New York : Riverhead Books, 2020.
Identifiers: LCCN 2019031361 (print) | ISBN 9780593086469 (hardcover) |
ISBN 9780593086476 (ebook)
Subjects: LCSH: Artists—Psychology. | Creation (Literary, artistic, etc.)
Classification: LCC N71 .S157 2020 | DDC 701/.15—dc23
LC record available at https://lccn.loc.gov/2019031361

Printed in China
1 3 5 7 9 10 8 6 4 2

BOOK DESIGN BY LUCIA BERNARD

To art, artists, and the art world,
and to my wife, Roberta Smith,
all of whom redeemed me

Agnes Martin, photographed by Alexander Liberman, 1973

INTRODUCTION

A rt is for anyone. I know this viscerally, as a would-be artist who burned out. I wrote about that recently, and ever since, I've been beset by questions. Every lecture I give, every gallery I visit, people ask me for advice. What most of them are really asking is, "How can I be an artist?"

In a time when it seems like there are so many more artists, museums, and galleries than ever; when art seems constantly in the news; when platforms like Instagram are conditioning us all to think visually, to find the aesthetic stimuli within our everyday lives—to allow "the little things [to] suddenly thrill you," in Andy Warhol's words—questions about creativity are in the air.

But how do you get from wondering and worrying to making real art, even great art?

Can I really be an artist if I didn't go to school? If I work full-time? If I'm a parent? If I'm terrified? Of course you can. There's no single road to glory. Everyone takes a different path. Yet over the years I've found myself returning to a handful of core ideas

again and again. Most of these ideas come from the simple act of looking at art, then looking some more, and from my own motor memories of my years as a fledgling artist. Others come from listening to artists talk about their work and their struggles. I've even lifted some from my wife.

Recently, I turned these nodes and nubs of advice into a feature for *New York* magazine, a kind of assemblage designed to take the reader "from clueless amateur to generational talent," as the magazine put it, "or at least help you live life a little more creatively." The article seemed to strike a chord, but it also got me thinking. As soon as the ink was dry, I started composing *new* rules, past the thirty-three I'd started with. Constellations of questions, reflections, and gentle directions, like "Make art for now, not for the future." Or "Don't worry about making it good—just make it." Or "Be nice, generous, and open with others, and take good care of your teeth." All of them intended to help people access what's already deep within them, and turn it into art.

Beyond this, though, I started thinking in a new way about some of art's most fundamental questions. Art, in all its forms, raises many persistent, strange, and even scary issues—challenges that can keep artists and onlookers intimidated, cynical, afraid to get started or to keep going. Even lifers like me.

Some of the fears that block us are circumstantial:

What happens if you didn't go to school for this? (I didn't.)

What if you're almost pathologically bashful? (Hi.)

What if you have impostor syndrome? (Almost everyone does; it's the price of admission to the House of Creativity.)

Or almost no money? (Welcome to the biggest bad club there is.)

Other questions are foundational:

Is the psychology of the work the same as the psychology of the artist? (Not really. And yet there must be a little bit of Jane Austen in every character in *Sense and Sensibility*, right? Just as there must be a bit of Goya in each of his monstrous figures. Or is there?)

How do you know if your art is working? (I remember the painter Bridget Riley saying, "If it doesn't feel right—it's not right.")

Deepest of all: What is art, anyway? Is it a tool the universe uses to become aware of itself? Is it, as the painter Carroll Dunham said, "a craft-based tool for the study of consciousness"?

I say *yes*—art is all of this and more. And your talent is like a wild animal that must be fed.

With all these questions floating around unresolved, how does any aspiring artist take that leap of faith to rise above the cacophony of external messages and internal fears and do their best work?

If you want to make great art, it helps to ask yourself what art *is*.

One way to think about art is that it's a visual language— usually non-verbal, arguably pre-verbal—with the power to tell us more in the blink of an eye (*Augenblick*, in German) than we might learn in hours of listening or reading. It is a means of expression that conveys the most primal emotions: lonesomeness,

silence, pain, the whole vast array of human sensation. Has any writer ever found the words to capture the internal suffering and external lamentation of Rogier van der Weyden's *Descent from the Cross*, from 1435?

Art is also a survival strategy. For many artists, making their work is as important, spiritually, as breathing or eating. Each day presents artists with new ideas and old beliefs, continuances and brutal breaks, enduring beauty and decay. Revelations present themselves, then slip away. At least once in a while, all artists must feel like Penelope from Homer's *Odyssey*— spending each day weaving tapestries from their own bank of stories, myths, fears, suppositions, dreads, and personal truths, only to awaken the next morning and unweave them all, changing, fixing, improving, purposefully dismantling. The artist is on a continually evolving path, accumulating experience but always starting over.

Being an artist means accepting this as part of the process. It also means embracing paradox—more than one thing being true at once. Art is open-ended; it exists in the gaps between explanation and the work itself. Each work of art follows its own structural logic. This can fill both artists and viewers with doubt. But doubt is a sign of faith: it tests and humbles you, allows newness into your life. Best of all, doubt banishes the stifling effect of certainty. Certainty kills curiosity and change.

Artists must also reckon with the uncanny feeling that by the time we've finished a new work, we've often ended up creating something different from what we set out to do. This feeling of surprise, of the unexpected, can delight or disappoint us. When you're creating, as the painter Brice Marden observed,

"you don't know what you're really going to get" until you finish a new work. The creative process is an inexplicable, inspired, crystallizing place where the artist becomes an audience to the work, almost doesn't know where it came from. Cindy Sherman said that creating art feels like "summon[ing] something I don't even know until I see it." Artists are terrific procrastinators, but our creative minds are working even when we're not; the coral reefs and tides of our inner life are still churning even when we're cowering, immobilized, from fear of work.

All art derives power from this background glow of time—that is, from the internal and external traces of all the decisions that went into its making. This produces a fabulous critical inversion: From the moment a new work is completed, the artist is parted from the work, and the viewer, in turn, becomes a participant in it. The viewer completes the work, unmaking and remaking it. "Every reader is—when he is reading—the reader of his own self," said Marcel Proust. If what's being read, seen, or heard is great art—a Bach cantata, a poem that keeps opening up for you, or a painting you've kept coming back to for a lifetime—it might be different every time you experience it.

What does this tell us? That we see not just with our eyes, but with all our faculties: our instincts, nerves, memories, senses of place and time and atmosphere, who knows how many others. Even the traditional five senses are subjective: Do I see the color of these letters the same way you do? What is the miracle of red? What does "rotten" smell like? What kind of music makes you mournful, or elated, or ready to dance? However these sensory receptors interact with the world and the self to create works of art, the result is a sort of alchemical transforma-

tion in the viewer's memory and body, forming new synapses in the brain, becoming an actual part of their own experience of and consciousness in the world.

I hope this book will bring you not only answers, but also new questions about your relationship with art. The process of making art is fluid and mercurial. It involves epiphanies large and small, turn-ons and turn-offs, symbols and structures in a constant state of change. And though its language may be purely non-verbal, even abstract, it has the power to carry meaning, affect our memories, change our lives. This is true whether a work derives its shape from basic forms—simple formats like the happy endings of comedy or the rote gloom of Gothic drama—or wholly new designs. These rules don't only apply to art, either. Ever since the original *New York* article appeared, I've heard from scores of writers, athletes, businesspeople, musicians, performers, chefs, and doctors, as well as hundreds of visual artists, all sharing how those rules helped them see their disciplines differently (while suggesting new ones themselves). Artists are artists, whatever their medium. And we all have a lot to learn from one another.

If you're an aspiring artist, I want you to remember: Nothing happens if you're not working. But anything can happen when you are. Henry Miller wrote, "When you can't create you can work." Noël Coward said, "Work is more fun than fun." (I learned this late, as a former long-distance truck driver with no degrees, who never wrote a word in my life until I was more than forty years old, avoiding creative work because I was fro-

zen by fear.) Like exercise, working can be awful *before you begin*, but once you start, it feels good. Give your work at least as much time, thought, energy, and imagination as you do other aspects of your daily routine. Art allows us all to access experiences and states that feel deeply human, important, pleasurable, yet sometimes very *other*. (This is one of the fun parts: that thrilling disorientation, the moment when you wonder, What is *this*?! *Where did it come from?*) I hope these ideas will help you delve into those states and maybe bring them about.

I also hope the ideas here will help you to start thinking more freely and creatively, and to trust your work itself to make you successful as an artist. Not that the goal is to be rich and famous, although those things are fine by me; I hope all artists make money, even the bad artists. No, I want you to trust yourself because that's what you'll need to get you through the dark hours of the creative night. I want you to open yourself to what the philosopher Ludwig Wittgenstein meant when he said, "My head often knows nothing about what my hand is writing." In other words: Learn how to listen, and the work will tell you what it wants.

So start your engines; jump in; feel your imagination engaging with reality, pushing away boundaries and conventions, and changing before your eyes.

Never feel intimidated. Art is just a container you pour yourself into.

Get to work!

Vivian Maier, Self-Portrait, *1955*

Step One

YOU ARE A
TOTAL
AMATEUR

▬▬▬▬▬

THINGS TO THINK ABOUT
BEFORE YOU EVEN GET STARTED

Shoog McDaniel, untitled, 2018

1.

DON'T BE EMBARRASSED

I get it. Making art can be humiliating. Terrifying. It can leave you feeling exposed, vulnerable, like getting naked in front of another person for the first time. It can reveal things about yourself that others might find appalling, weird, boring, or stupid. You may fear that people will think you're abnormal, dull, untalented. Fine. When I work, my mind races with doubts: *None of this is any good. It makes no sense. Anyone who sees this will know I'm a dope.* But art doesn't have to make sense. Art is like birdsong: it's made of patterns, inflections, shadings, shifts—all things that have emotional and perceptual impact, even if we can never really translate their meanings. Every work of art is a culturescape of you, your memories, the moments you spent working, your hopes, energies, and neuroses, the times you live in, and your ambitions. Of the things that are engaging, mysterious, meaningful, resistant over time.

Don't worry about whether your art "makes sense." The faster your work makes sense, the faster people will lose interest. Let go of being "good." Start thinking about creating.

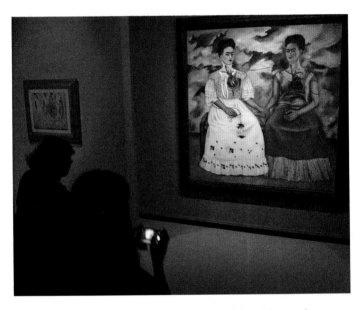

Frida Kahlo's The Two Fridas *(1939) inspiring visitors to the Grand Palais, Paris. (Photographed by Jacques Demarthon, 2016)*

2.

"IMAGINATION IS MORE IMPORTANT THAN KNOWLEDGE."

—ALBERT EINSTEIN

The imagination is endless and always there. It's a lens, a tool that enlarges life, that animates your own Cambrian ocean of past, present, and potential future forms. It adds what Samuel Taylor Coleridge called "gorgeous nonsense," making unreal things real and real things unreal. Pledge allegiance to it; live up to it; honor and listen to it; take pleasure in it; let it be your magic lantern and flying carpet. Your imagination extends your mind to the world around you. It pressurizes, composes, decomposes, and connects thoughts. It's inseparable from you and will be with you on the day you die. "The imagination is not a state," said William Blake. "It is the human existence itself."

Creativity is what you do with your imagination. Write down your flights of fancy, your moments of wonder and fear, your dreams and delusions of grandeur. Then put them to work.

Make the imagination your compass star.

Louise Bourgeois in 1975, wearing her latex sculpture Avenza,
photographed by Mark Setteducati

3.

"TELL YOUR OWN STORY
AND YOU WILL BE INTERESTING."
—*LOUISE BOURGEOIS*

Amen, Louise. Don't be reined in by other people's definitions of skill or beauty, or be cramped by what is supposedly *high* or *low*. Don't stay in your own lane. Drawing within the lines is for babies; making sure things add up is for accountants. Proficiency and dexterity are only as good as what you do with them. But also remember that just because you're telling your own story, you're not automatically entitled to applause. You have to earn an audience. And don't expect to accomplish that with a single, defining project. Artists can't capture everything about themselves in a single work, or reflect every side of themselves in every new work. You have to be a little detached from your art—enough to see what you're doing clearly, to *witness* it, and to follow it. Take baby steps. And take pleasure in those baby steps. Even when you're making it up, make it your own.

4.

RECOGNIZE THE *OTHERNESS* OF ART

Is the writer much more than a sophisticated parrot?" Gustave Flaubert wondered. Most artists know this feeling—that we're being led by something outside ourselves. We all choose our styles, our materials, modes, means, tools, and so on, but the work we create isn't entirely a matter of conscious choice. I never quite know what I'm going to write until I write it—and then I'm not sure where it came from. This is art's *otherness*. It's so powerful that you might sometimes wonder if art is using us to reproduce itself—if art might be a self-replicating cosmic force (or a fungus?) that has colonized us into symbiotic service.

This can be thrilling. It can also be unsettling. "It's like a ghost is writing," Bob Dylan said, "except the ghost picked me to write the song." Don't let this creep you out. Instead, learn to trust it.

5.

ART IS NOT ABOUT UNDERSTANDING . . . OR MASTERY

IT'S ABOUT DOING AND EXPERIENCE

No one asks what Mozart or Matisse *means*. Or an Indian raga or the little tripping dance of Fred Astaire and Ginger Rogers to "Cheek to Cheek" in *Top Hat*. Forget about making things to be understood. I don't know what ABBA's music means, but I love it. Oscar Wilde said, "The moment you think you understand a great work of art, it's dead for you." *Imagination* is your creed, sentimentality and lack of feeling your foes. All art comes from love—love of doing something. Look at Bosch's horrors in hell; they are rendered with loving attention, care for every stroke, nuance, and color. Even Francis Bacon's angry portraits come not just from his fury at his subjects, but also from a *love of painting*. Even if we're in agony while working, it's still some kind of love that drives us on against the current.

6.

EMBRACE GENRE

Genre is a major factor in the way we think about art. The portrait is a genre; so are the still life, the landscape, animal painting, history painting. Comedy and tragedy are genres. So are sonnets, science fiction, pop, gospel, and hip-hop. Genres possess their own formal logic, tropes, and principles. They create useful commonalities of response and place your work in the flow of history. Mary Wollstonecraft Shelley invented the modern Gothic in a fever dream of writing that became *Frankenstein*; horror writers have been revisiting the story of the doctor and his lonely monster ever since.

What's the difference between genre and style? Style is the unstable essence an artist brings to a genre—what ensures that no two Crucifixions, say, look the same. Oscar Wilde said that style is what "makes us believe in a thing." *Madame Bovary* is a simple morality tale; Flaubert's style makes it a masterpiece. Dolly Parton's "Jolene" is a classic country story song; the vulnerability of her performance is what makes you die inside when you hear it. A fresh style breathes life into any genre.

7.

RECOGNIZE CONVENTION— AND RESIST CONSTRAINT

What if I told you that any new piece of art already looks a certain way *before* you make it?

If it's a painting, for instance, it's likely to be square or rectangular; it'll have four corners and straight sides; it'll be made by covering a more or less flat surface with liquid or spreadable material, using a brush, knife, or similar device; it'll hang on a wall. You know what styles or ideas you have in mind; what metaphors you favor, structures you might use, sentiments you want to express. This isn't otherness. It's the passive power of convention.

Convention can be good or bad; used consciously and inventively, it can be beautiful. But conventions are limits, and limits should be recognized for what they are. They are subtle forces pulling on your work—and they can exert a dangerous hold. Be on guard! Stay awake to their implications. Question your assumptions, push back on them, play around with them. Any convention can be turned into a great tool, hijacked in service of your own vision.

Exercise

COMPARE THESE EIGHT NUDES

Forget the subject matter—what is each of these paintings actually *saying*?

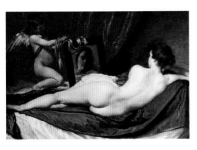

Diego Velázquez,
The Rokeby Venus, *1647*

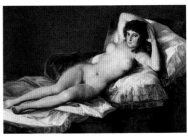

Francisco Goya,
The Naked Maja, *1797-1800*

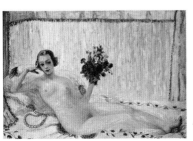

Florine Stettheimer, A Model
(Nude Self-Portrait), *1915*

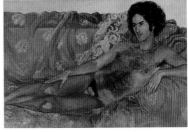

Sylvia Sleigh,
Imperial Nude: Paul Rosano, *1977*

Édouard Manet, Olympia, *1863*

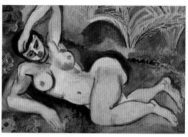

Henri Matisse, Blue Nude, *1907*

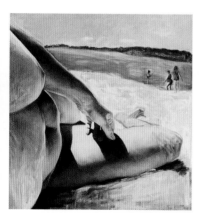

Joan Semmel, Beachbody, *1985*

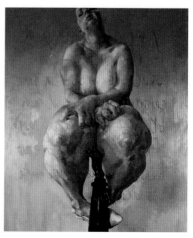

Jenny Saville, Propped, *1992*

8.

CAST YOUR NETS INTO THE WATERS

You are a pearl diver, a rock collector, a shell hunter combing the beach for inspiration. You're an archaeologist of forms, tropes, sensations, spaces, light, identities, micro- and macrocosms, moss. A pattern-recognition machine and code breaker. You are probing for ideas even if you don't know what you're hoping to find. Anything goes. Never stop throwing your nets into those fundamental waters. Throw them out, haul them back in again—even when they're empty, that frantic energy, that perverse need to keep looking till you can't imagine finding more, can keep you receptive to new metaphors, materials, and meaning.

9.

DEVELOP FORMS OF PRACTICE

Keep a pocket-size sketch pad with you at all times. Whenever you have an odd moment—over your morning coffee, as you're riding on the subway, while sitting in the dentist's waiting room—practice looking at your own hands and drawing them. Fill your pages with hands, lots of them on the same page, hands over hands over hands. Other people's hands, if you want to. They don't have to look right. You can draw other parts of your body, too—anything you can see, with your own eyes, in the moment. Play with scale: make things bigger, smaller, twisted, gnarly, finely rendered. You can even use a mirror if you want to draw, say, the place where your cheek turns into your mouth. Don't make it up! The goal is first to learn how to look—and then to *describe*, with your pencil or pen, what you see.

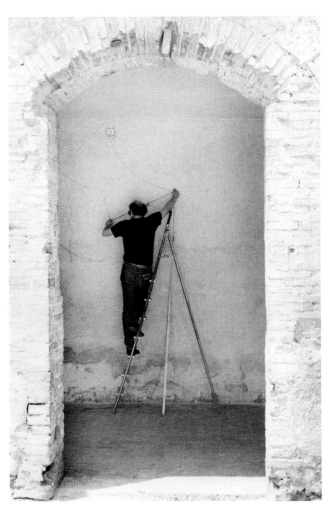

Sol LeWitt installing Wall Drawing #136, *Chiostro di San Nicolò, Spoleto, Italy, photographed by Giorgio Lucarini, 1972*

10.

GET LOST

T he idea becomes the machine that makes the art," said Sol LeWitt. That doesn't mean you should turn yourself into a machine. Most machines are programmed to repeat one action without variation. Predictability is good for computers, but it's death for artists. Rigid adherence to formula can trap you in a cul-de-sac, limiting your grasp of life around you, stifling improvisation. Avoid lingering on the well-worn path; you don't want to be a minor example of someone else's major style or idea. It's a far better thing to let yourself get lost than never to stray at all.

What LeWitt was getting at is that serious artists tend to develop a kind of creative mechanism—a conceptual approach—that allows them to be led by new ideas and surprise themselves without deviating from their own artistic principles. As an artist, you're always studying your environment, absorbing sensations, memories of how things work and don't work. The goal is to create a practice that allows a constant recalibration between your imagination and the world around you.

There's no road map for art. Get lost!

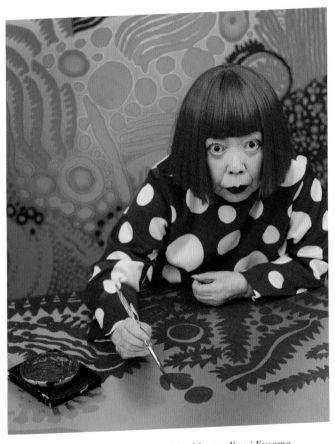

Even under long-term mental health care, Yayoi Kusama has been prolific throughout her career. (Photographed in her studio by Jeremy Sutton-Hibbert, 2012)

11.

WORK, WORK, WORK

The artist Sister Mary Corita Kent said, "The only rule is work. If you work, it will lead to something. It's the people who do all of the work all the time who eventually catch on to things."

I have tried every conceivable way to conquer work-block—that fear of working, which is a fear of failure. There's only one method that works: Just work. And keep working.

Every artist and writer I know claims to work in their sleep. I do all the time. Jasper Johns famously said, "One night I dreamed that I painted a large American flag, and the next morning I got up and I went out and bought the materials to begin it." Just think: You might have been given a whole career in your dreams and not heeded it! It doesn't matter how scared you are; everyone is scared. Work, you big baby! Work is the only thing that banishes the curse of fear. As Anne Lamott writes, "Butt in chair. Start each day anywhere. Let yourself do it badly. Just take one passage at a time. Get butt back in chair."

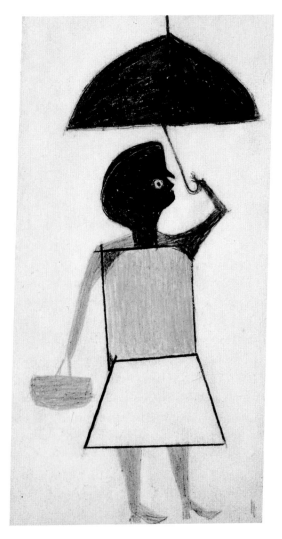

Bill Traylor, Woman in Green Blouse with Umbrella, *c. 1939*

12.

START NOW

So many people waste so much time worrying that "it's too late to start." They give their energies to excuses for why they can't get to work. Bollocks! Many great artists, writers, actors, and others started late. Henri Rousseau didn't begin painting till he was in his forties. Julia Margaret Cameron didn't become a photographer until she was forty-eight. One of America's greatest so-called outsider artists, Bill Traylor, a former slave, didn't start making art till he was eighty-five.

You can start anytime. I know this firsthand, because I wasted decades not writing. I had a million stupid reasons: being afraid, feeling untrained, convinced I was unworthy, that I had nothing to say, that I was a fake, that I lacked the time or money or connections I'd need to make it in the art world. I'm not sure what got me to stop not-writing. Maybe it was when my wife, the art critic Roberta Smith, read my early work and told me, "If you don't get better, I'm going to kill myself." (The person closest to you shouldn't have to sugarcoat critique.) Maybe I knew that nothing could be worse than what I was feeling. So, at forty, I finally got serious—living proof that it's never too late.

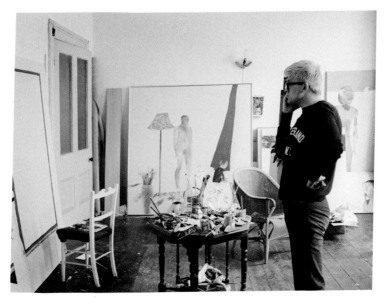

David Hockney, photographed by Tony Evans, c. 1967

Step Two

HOW TO
ACTUALLY
BEGIN

———

AN INSTRUCTION MANUAL
FOR THE STUDIO

Henri Matisse, working in bed, photographed by Clifford Coffin, 1949

13.

START WORKING WHEN YOU WAKE UP

O r as soon as possible thereafter. If you can get into it within the first two hours of the day, that should be early enough to get around the pesky demons of daily life. Four hours is too long; the demons will take you down. If you don't have time to make art until you get home from work, or after you put the kids to bed, give yourself ninety minutes— no more—to rest, contemplate, procrastinate, before starting your creative work. Your body and mind will thank you.

14.

MAKE YOUR MARK

I f you're worried about drawing, start by making simple marks. Tell yourself you're just playing, experimenting, outlining, seeing what looks like what. If you can write, you already know how to draw. You already have a form of your own, a style of making letters and numbers and your own special doodles. (Don't you love how you write the first letter of your name?) These are forms of drawing, too.

While you're making these marks, pay attention to the physical feedback you're getting from your hand, wrist, and arm—but also from your eyes, your ears, even your sense of smell and touch. How long do your marks extend before you need to lift the pencil and make a different mark? Do you lift the pencil or just cut back, never leaving the surface? Why? What does each action do? Which is better for you? Make those marks shorter or longer. Change the ways you make them: Wrap your fingers in fabric to change your touch; try your other hand to see what it does. Put plugs in your ears; see what silence does. All these things are telling you something. Get very quiet inside yourself and listen to them.

As you work, pay attention to everything you're experiencing. Don't think *good* or *bad*. Think *useful, pleasurable, strange, lucky.* Glenn Gould practiced with radios and a TV blasting so loud next to his piano that he was free not to listen to what he was playing, to better concentrate on feeling it. Hide secrets in your work. Dance with these experiences, collaborate with them. They're the leader; you follow. Soon you'll be making up steps, too, doing visual calypsos all your own—ungainly, awkward, risky. Who cares? You'll be dancing to the music of art. Feeling what flow is.

The art critic Harold Rosenberg advised artists: "If you have no ideas, draw. . . . If you are depressed, draw; if you get drunk, go home and start a picture. If there is shooting outside the window, go on drawing." Carry a sketchbook with you at all times. Take pictures on your phone if that helps you to remember things. When your thoughts start racing, don't be passive—get them down on paper. Cover a one-foot-square sheet with marks. Instead of filling the whole page edge to edge, think about *how to use the space*: Can you make two similar marks look different, exist on different planes, do different things? Think about what shapes, forms, structures, configurations, details, sweeps, buildups, dispersals, and compositions appeal to you.

Now do this on another surface—any surface—to start yourself thinking about what kinds of materials appeal to you. Draw on rock, metal, foam core, coffee cups, labels, the sidewalk, walls, plants, fabric, wood, whatever. Just make marks; decorate surfaces. Don't worry about doing more. All art is a form of decoration.

Next, draw whatever happens to be within the square foot in front of your desk, easel, bed, subway seat, or lap. This can be tight, loose, abstract, realistic. It's a way for you to start assessing how you see objects, textures, surfaces, shapes, light, dark, atmosphere, and patterns. It can also tell you what you may be missing. Now draw the same square foot from the opposite side. You are already becoming a better artist, even if you don't yet know it.

Exercise

MAKE A DRAWING USING ONLY ERASURE

1. Cover a surface with pencil, charcoal, chalk, fabric—anything that can be removed.
2. Using erasers, rags, turpentine, scissors—even your fingers—make a new image by removing parts of that layer.

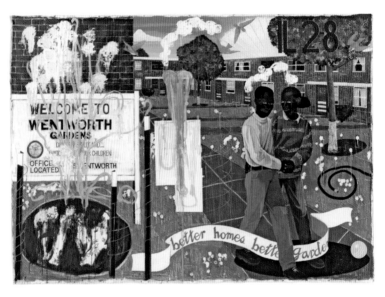

Kerry James Marshall, Better Homes, Better Gardens, *1994*

15.

GET SOME PERSPECTIVE

Perspective is often said to have been invented, or discovered, in Italy at the beginning of the fifteenth century. This is nonsense.

Ancient Roman wall paintings have a highly evolved, mathematical system of one-point perspective. They also have what's called *atmospheric perspective*, wherein the lightest objects appear closest to the viewer and receding edges and planes are represented through shading. The Greeks understood perspective. So did the Egyptians, millennia before that. Even cave paintings have perspective: Animals that are closer to us appear larger, those farther away appear smaller. Mammals are grouped in space in relation to one another in ordered ways. All these cultures had perspective; they just weren't that into it. I imagine they found it a middle-class gimmick, an artificial constraint. They were never seduced by it the way we are.

The East never had any use for what we think of as perspective. Ditto sub-Saharan Africa and Oceania. Byzantine painters told the same biblical stories as Renaissance painters; they just used thousands of different ways of showing space—ways that

were often a lot more fun. It's only been since the early 1400s that the West (and *only* the West!) has gone all-in on one technique for representing space. From around the Renaissance to roughly the early nineteenth century, perspective exerted a death grip on artists. It was a time that saw the creation of great art, of course, but also a stultifying academicism. Then something wonderful happened: a stunning string of artists—from Delacroix, Corot, and Courbet, to Manet, Monet, and Morisot, to van Gogh, Gauguin, and Cézanne, to Mondrian and others—shattered the strictures of perspective. By the time Ellsworth Kelly's flat shapes come along, in the 1940s, space is gone altogether. Art has been dancing on perspective's grave ever since.

Here's how all this applies to you:

Exercise

TRY ON SOME STRONG STYLES

Make a drawing of anything you like. Keep it simple. Then look up each of the strong artistic styles I list below. (A strong style is one you know at a glance: a Lichtenstein dot painting, a Picasso portrait, a Hokusai print.) Each style navigates perspective differently. Don't worry about their history; just get a sense of how each style looks. How does it use its elements—shape, color, form, outline, surface effects—to place the viewer in space?

Now, take your drawing and remake it in an Egyptian style.

Then in a Chinese ink-drawing/-painting style.

Then in a Western-perspective style.

Then in Cubist space (where the eye moves around the subject but sees it all at once—making every side of the image visible in the frame).

Then in cave-painting style. (You might try this on a bumpy surface.)

Then like Keith Haring.

Then like Kara Walker.

Then like Georgia O'Keeffe.

Then digitally.

You've now started training your eye—and your *hand*—to detect different linear, planar, and spatial domains, and to understand how style affects perspective . . . and perception.

33

16.

IMITATE . . . THEN SEPARATE

Imitation is a key to learning. We all start as copycats, trying on other people's forms and styles for size. It's fine! Just don't stop there. If *all* you do is pastiche, your work will end up as predictable art-lite, or picturesque kitsch. Topological form, structure, and originality are more complicated than just mastering a technique or mashing up two unrelated styles. This kind of pastiche might seem clever, but it can quickly devolve into a soup of underconceived, overly obvious hybrids: Pop Minimalist, Abstract Surrealist, Street Cubist, Graffiti Impressionist. Half-baked forms without meaning. Art isn't about playing games with aesthetics.

If you like experiments with pastiche, focus on the spaces *between* all these styles, forms, structures, tools, visual syntaxes, and your imagination. These are the gaps you need to probe. Keep at it until you feel the work start to become your own. It happens all the time. Think of yourself as landing in a huge coliseum filled with ideas, avenues, ways, means, electromagnetic pulses, materials, and internal game theories. Make these things yours. This is your house now.

17.

USE YOUR STUDIO

The studio is your sanctum: an inventor's laboratory, teenager's bedroom, mechanic's garage, séance chamber, fortress of solitude, prison cell, ecstasy machine, wormhole, and launch pad. This is true even if it's just a dining room table you clear off at night. You are a god here, responsible for everything that happens—and *not* responsible for anything you don't want to be. It's a ritual arena where you will achieve maximum diversity in a minimum of space. Here you can look for new architectures, create your own constellations—and *follow through* on any idea you wish, no matter how silly-sounding. Rembrandt seems to have worn a magic hat in the studio. Dress in your own abracadabra garments.

In the studio, get into your body. Breathe, pace, do whatever it takes to prepare yourself. Leave something a little unfinished each day; it'll help you get back into your work the next morning. The decor of your studio will bleed into your imagination, so think about the postcards, personal objects, other artworks you display there, and change them up regularly. The studio should be a place of no shame, where you're open to surprise

and humiliation; where you're never afraid of silence; where you sit sometimes for hours just looking at what you've made, not knowing but musing, letting your mind drift. And tomorrow you come back and work some more.

Exercise

FORGET BEING A GENIUS AND DEVELOP SOME SKILLS

All artists should know the feeling of simple work with raw materials. Try these:

- Prune a tree.
- Build a clay pot. Learn how to do a basic glaze. And how to fire the pot.
- Sew together two pieces of fabric. Maybe add a third. Then a clasp or button.
- Use a lathe to carve a wooden bowl.
- Make a lithograph, etching, or woodblock print. Please try at least one printmaking technique, even if you do it very badly.

You are now in possession of ancient knowledge.

18.

PICASSO AND MATISSE AT THE BORDER

Study the long career of Pablo Picasso and you might notice something: The subjects of his paintings don't run off the canvas. His figures and faces aren't cut off. Almost every shape, body, plane, line, breast, anus, face, or form he painted fits within the four sides of the canvas, crammed against the edges or dancing with them; everything is held under optical pressure by the four borders. This produces a distinctive visual tension. Picasso is classical this way.

His friend and rival Henri Matisse followed no such classicism. In his paintings, legs and feet go off canvases; heads are cropped willy-nilly; elbows are cut off. Patterns shoot right past the edges of his work. Matisse's idea of composition and space is like a wildflower garden, a long gaze at the night sky, a changing cloud.

Every artist has his or her own relationship with these borders. The painter Eric Fischl has talked about what he calls "heaven" and "hell" compositions. In heaven compositions, things are orderly, homogeneous. Priority is given to the whole

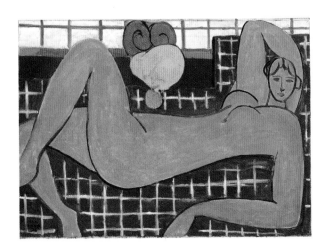

Henri Matisse, Large Reclining Nude, *1935*

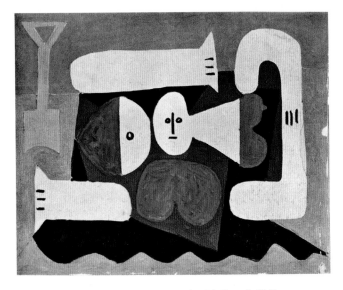

Pablo Picasso, Nude on Beach with Shovel, *1960*

over its parts. Hell composition is marked by chaos; it's emulsifying, broken, textural, and it can veer to extremes.

Brice Marden is an artist whose approach to composition recalls Picasso, but with a Matissean tilting at color. He begins with a rectangular or vertical field of secondary or tertiary color. (Though he's known to fill in the background last—a trick worth trying.) Against this field, he applies plump, flat, snaking lines that spiral inward, twisting back toward the borders, gracing or running along the top or bottom of the canvas like intelligent sightless organisms feeling their way via electromagnetic charge. Marden's work is about *itself*: its shape, space, scale, size, internal architecture, process. It's about form remembering and replicating itself.

If snakes in a box can do this, you can, too.

Exercise

Study the composition style of each of these artists (or genres)—don't read, just *look*—and identify each (loosely) as heaven or hell.

Robert Rauschenberg

Jasper Johns

Ellsworth Kelly

Frida Kahlo

Georgia O'Keeffe

Willem de Kooning

Joan Mitchell

Katharina Grosse

Jackson Pollock

Louise Bourgeois

Sol LeWitt (wall drawings)

Tintoretto

Chinese ink-drawing

Michelangelo

Claude Monet

J. M. W. Turner

Paul Gauguin

Francis Bacon

Damien Hirst (dot paintings)

Katsushika Hokusai

Cave paintings

Francisco Goya (Black Paintings)

Henry Darger

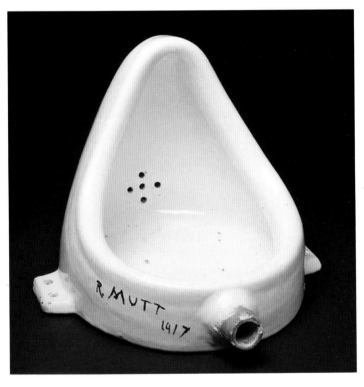

Marcel Duchamp, Fountain, *1917*

19.

EMBED THOUGHT IN MATERIAL

What does this mean? An artwork should express thought and emotion. (I contend that the two can't be separated.) Your goal as an artist is to use physical materials to make these thoughts and emotions, however simple or complex, accessible to the viewer. Materials have the potential to take a previously empty space and suffuse it with new meanings—meanings that will continue to transform over time. Eric Fischl has said that he "wanted to paint what couldn't be said." All artists are trying, on some level, to do the same.

Some artists work with oil and canvas, others with stone and chisel; some use gallery spaces, museums, or town squares as staging places; others use performance, digital signals, city walls, desert rocks, string, steel, glass, mud, whatever. My materials are words and sentences, similes and conjectures; they are all embedded with the way I think and feel. If you're able to do this with the materials you choose—even if viewers misinterpret your work—it will strike them as distinctly *yours*. And this will give your materials agency and energy.

If you fail to use your materials fully, your work may end up starved for ideas. Don't rely on wall text to do the work! Recently I was looking at a series of ho-hum black-and-white photographs of clouds when a gallerist sidled up to inform me: "These are pictures of clouds over Ferguson, Missouri. They're about protest and police violence." I bristled. "No, they're not! They're just pictures of clouds and have nothing to do with anything. They're not even interesting as photos!" A work of art cannot depend on explanation. The meaning has got to be there *in the work*. As Frank Stella said, "There are no good ideas for paintings, there are only good paintings." The painting *becomes* the idea.

There is a different way. Without knowing anything about the English painter J. M. W. Turner, spend some time with his work and you'll see his drive to push oil paint to its limits, to make landscape as important as history painting, to shatter and abandon Renaissance space. Turner didn't care about contours or readability; he probably painted with all manner of tools, even his fingers, and his thoughts about nature were conflicted, imaginative, breathtaking, even when muddy or overdone. *All of this is in the material.*

Or consider Marcel Duchamp. In the winter of 1917, at the age of twenty-nine, Duchamp purchased a urinal at J. L. Mott Iron Works on New York's Fifth Avenue, signed it "R. Mutt 1917," gave it the title *Fountain*, and submitted it to the non-juried Society of Independent Artists exhibition. *Fountain* is an aesthetic equivalent of the Word made flesh, an object that is also an idea—that idea being that any object can be an artwork. In 2004 it was voted the most influential artwork of the twentieth

century. Two years after *Fountain*, Duchamp literally drew a mustache on a postcard *Mona Lisa*, gave it the title *L.H.O.O.Q.*—an acronym for a cheeky French phrase that translates roughly as "The lady has a hot ass"—and completely transformed the image. What was he doing? Showing us that the artist can embed thought in any material—just as the first artists used color and line on stone to create cave paintings, which remain one of the most advanced and complex visual operating systems ever devised by our species. As Jay-Z put it, you make materials "do more work than they normally do, to make them work on more than one level."

With this in mind . . .

Exercise

MAKE A MEMORY TREE

Step one: Using any material, on any surface, make, draw, or render a memory tree of your life. From this work we should be able to know something about you *other than* what you look like or how many siblings you have. Include anything you want: pictures of you, your friends, or your exes; texts, places you remember, signs, maps, objects, found photos, and so on. The goal is to create something that gives others access to you. This should take no longer than three days. Period.

Step two: Show this new tree to someone who doesn't know you well. Tell them only, "This represents my life up to now." Then ask them what the work tells them about you. No clues. Don't worry about whether they like it. That doesn't matter.

Step three: Listen to what they say.

20.

ART IS A FLATWORM

Like a flatworm, art possesses the astounding ability of regeneration. Split your work in any way—lengthwise, widthwise, into irregular pieces, using just one idea or element from the whole—and it can grow into an entirely new organism. This is true down to 1/279th of the organism. Every part of this new entity, in turn, will have the ability to engender another new form—which may itself grow into a self-sufficient organism that retains the memories of the original. In this way, art remembers itself.

Vivisect yourself. Any material, gesture, color, surface, idea can grow again into a new branch of your work. It will have the potential to develop in unforeseen ways, to accrete and conjoin into new structures that will almost inevitably mean more than you've intended. This work of severing, reconsidering, repositioning, is the origin of what Salvador Dalí called "a delirium of interpretation." It's why art has likely been with us since the beginning. Art is like a burning bush: it puts out more energy than went into its making. This is what is meant by *ars longa*.

Exercise

Using projection, tracing paper, or any other appropriative technique, make a drawing of a found image or photograph. Make it as perfect and as true to the original as you possibly can.

Then draw the same object in the exact same way—but this time *invent* 50 percent of it. Ad lib, riff, change it slightly or greatly or entirely for that half.

Finally, put the image away and render it from memory. When you re-create something from memory, you're necessarily putting yourself *inside* the work—between what you saw and what you think you saw, in dialogue with the image, the materials, your memory, yourself, and more.

Those last two drawings? They're flatworms.

21.

LISTEN TO THE WILDEST VOICES
IN YOUR HEAD

I have my own sort of School of Athens in my head. A team of rivals, friends, famous people, influences, dead and alive. They're all looking over my shoulder as I work. They all make observations, recommendations, suggestions. None of them are mean. I use music a lot. I think, *Okay, let's begin this piece with a real pow!* Like Beethoven. Or I listen to the Barbara Kruger in my head, who says, *Make this sentence short, punchy, declarative, aggressive.* Once in a while, Led Zeppelin chimes in: *Try a hairy experiment here. Let it all show, be it weird, messy, overblown, absurd.* All the Sienese paintings I've ever seen beg me, *Make it beautiful, indulge the erotics of looking.* D. H. Lawrence pounds on the table, demanding *voice*; Alexander Pope tells me to get a grip; Whitman pushes me on to merge my work with anything; Melville gets grandiose; and Proust drives me to extend my sentences till they almost break and my editors step in to cut them down.

Think about the voices in your private psychic pantheon. Get to know them. They'll always be there when things get tough.

Work like Fable II *(1957) marked Philip Guston as an Abstract Expressionist—a generic AbEx guy.*

With breakthroughs like Riding Around *(1969), he became Philip Guston.*

22.

FIND YOUR OWN VOICE

THEN EXAGGERATE IT

I f someone says your work looks like someone else's and you should stop making it, I say don't stop—not yet. Do it again. Do it a hundred, or a thousand, times. Then ask an artist friend, someone you trust, whether your work still looks too much like the other person's art. If your friend says yes, try another path.

Imagine the risk Philip Guston was taking in the 1960s when he followed his own voice and went from being a first-string Abstract Expressionist to painting clunky, cartoony figures smoking cigars, driving around in convertibles, and wearing KKK hoods! He was all but shunned for this. He followed his voice anyway. These paintings are now some of the most revered artworks of the entire period. (His story is also an example of how artists can't always control, or even predict, the results their machine creates.)

23.

CLEAR THE STUDIO

When you're stuck, muddled, or you feel you can't move on, try clearing your studio. Or cleaning it, picking up, sweeping, moving things around, making new piles of old clutter. (My wife is a world champion of this last technique—which helps her write perfect text.) You can do this every day. It's a way of being physical, breathing into the work, creeping up on a task at hand. Maybe you'll find something in a pile that sparks a new idea, mushrooms into fresh growth. And you'll be making space for what Goethe requested on his deathbed: "More light."

24.

THERE ARE NO WASTED DAYS

Your artist's mind is always working, even when you think it's idling. In the studio, even doing nothing can be a form of working. This is also true when you're out walking, traveling, worrying, staying awake all night, whatever. *All* these things will be part of your work. Even when you seem to be going nowhere, things are happening. You *are* your method; your life is part of your work. "A bad day is a good day," the painter Stanley Whitney said, "because a bad day is when you're trying to take it to a different level."

25.

KNOW WHAT YOU HATE

It's probably you.

Exercise

Make a list of three artists whose work makes you uncomfort-
able. Then make a list of three specific things about each artist's
work that make you feel this way. Read the list back closely; ask
yourself if there's something about what these artists do that
you share. Really think about this. It's also a great way to dis-
cover how certain qualities might be interesting to you, might
speak to you, even if you find them disquieting. Bad things can
be great doorways.

26.

FINISH THE DAMN THING!

Everyone thinks their work might be better, if only they had a little more time with it. Amy Sherald, who created the celebrated official portrait of Michelle Obama, says that with "every single show I've had for the past three years, the paintings left my studio wet," that as soon as they go out the door she's "literally following them to the truck with a paintbrush like, 'One more thing!'"

Your own work might be just as important as Sherald's—but it will never be perfect. Perfect doesn't exist. Nothing is ever really *just right*; there's always more you can do. Too bad. It's as good as it can be right now, and that's probably more than good enough. You'll make the next one better, or different, or more like yourself. Do not get hung up working on one super-project forever. For now, make something, learn something, and move on. Or you'll be buried waist-deep in the big muddy of perfectionism.

Andy Warhol in his studio, photographed by Hervé Gloaguen, 1966

Step Three

LEARN TO THINK LIKE AN ARTIST

———

THIS IS THE FUN PART

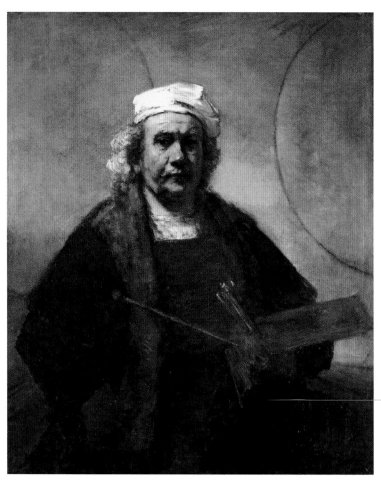

Rembrandt, Self-Portrait with Two Circles, *1665-1669*

27.

ALL ART IS SUBJECTIVE

What does this mean? We have consensus that certain artists are good, but you may look at a Rembrandt and find yourself thinking . . . *It's pretty brown.* That's fine! It doesn't mean you're dumb. (See 31, "The Cézanne Rule.")

What does *subjective* mean? It means that, though the text never changes, every person who sees *Hamlet* sees a different play. Moreover, every time *you* see *Hamlet*, you see a different play. This is the case with almost all good art. It's always changing; every time you see it anew, you think, *How did I miss that before?*

This brings us into one of art's most metaphysical chambers: Art is an unchanging thing that is never the same—a static entity that somehow, whenever you experience it, seems to be inhabited by poltergeists spontaneously generating new messages for you.

What effect should this have on your work? Maybe just this: Let it take some weight off your shoulders. Stop fiddling and move on. The work will keep changing itself.

Margaret Bourke-White photographing New York from the
Chrysler Building, photographed by Oscar Graubner, c. 1935

28.

LOOK HARD. LOOK OPENLY.

Looking hard isn't just about looking long; it's about allowing yourself to be *rapt*. Make yourself a seeing machine. A wonderful moment will come when you realize you're no longer just seeing the sky; you're reckoning with the blue as something more (and other) than itself.

Looking openly means allowing yourself to access new sources of visual interest. Practice this openness, and the world will grow larger and richer around you. Looking openly gives you agency, the power to become responsive to every square millimeter of what you're seeing.

Seeing the world in these ways can free you from despair. The artist Gaylen Gerber recalls visiting the Art Institute of Chicago after 9/11, when it felt like art might no longer have a purpose, and how the simple act of "looking at shiny plastic furniture from the '60s and '70s" revived him.

Train yourself to look deliberately, and the mysteries of your taste and eye will become clearer to you. You will glean what Emerson meant in saying that "all things swim and glitter." And what Adele means by "rolling in the deep."

29.

ARTISTS ARE CATS. ART IS A DOG.

I know this sounds ridiculous. But call your dog and it comes right over to you. It places its head in your lap, slobbers, wags its tail, asks to go for a walk: a miraculous direct communication with another species. Now call your cat. It might look up, twitch a bit, perhaps go over to the couch, rub against it, circle once, and lie down again.

What am I saying? The way the cat reacts is very close to the way artists communicate.

The cat is not interested in direct communication. The cat places a third thing between you and it, and it relates to you through this third thing. Artists, like cats, communicate abstractly, at a remove. This is why artists hate to be asked what their work means. Even if what they make is a picture of a landscape, or a race riot, it's not "about" only those things. It's about much more—including *itself*, its materials and how they were used, and how the artist sees the world.

As for art itself, that's much more like a dog: never quite behaving, making a mess, costing a lot, always making you get supplies, but paying you back in wonder and delight.

30.

SEE AS MUCH AS YOU CAN

Critics see by standing back: by looking at a whole show, comparing individual works, marking advances, regressions, repetitions, failures within the context of an artist's previous work and that of their peers.

Artists see very differently. They get up *very close* to a work. They inspect every detail: its textures, its materials, its makeup. They touch it, look at its edges, peer at the object from every angle. (You can always tell the artists in museums—they're the ones with their faces one inch from the surface of a work. Like one dog sniffing another.)

What are the artists doing? They're seeing how it was made—what techniques, ingredients, gestures, and accidents are in play. When I've asked artists what they're looking at so intently, they always say things like "the shininess," "the bumpiness," "the scratches on the side," "the way it's mounted," "the printing technique," "the pink Styrofoam backing," "how they left the flies in the surface." All these little matters loom large when they appear in someone else's work. This is why all artists know that bad art teaches you as much as good art—maybe more.

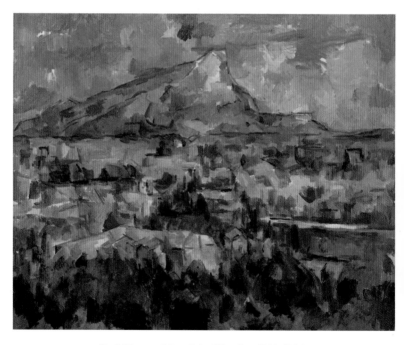

Paul Cézanne, Mont Saint-Victoire, *1902-1904*

31.

THE CÉZANNE RULE

Sometimes, it can take years to see what others see. For decades, I stared at the work of Paul Cézanne and thought only, "Apples, choppy mountains, bathers—*meh*." I never gave up, though, because it's my job to understand what the consensus sees. So I kept coming back to Cézanne. One day, everything went kablooey. What once looked like dull disequilibrium, I now saw as scrims of painted space, masterfully orchestrated planes and subtle shifts, layers of changes in focus, patterns changing before the eye like wheat fields in the breeze. All this held together by a visual architecture as strong as the temples of ancient Greece. Ever since, every Cézanne I've seen has left me breathless. I understand now why Matisse called him "a sort of God," why Picasso said, "He was like our father."

If you're stymied by some artists, keep their names on a list and keep coming back to them. You might start with Rembrandt, unflinching in depicting the physical weight of the world, ever vulnerable. Or Constable, as elementally tactile as any artist who ever lived. Once an artist finally makes sense to you, take on a new one. You owe this to yourself as a seeing machine.

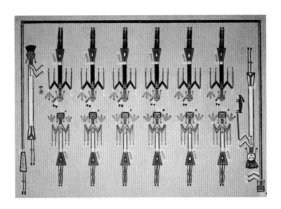

Navajo sand paintings serve as pleas to the gods . . .

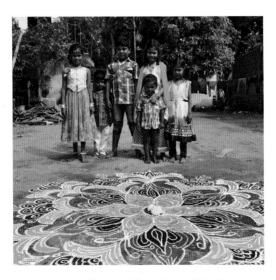

*. . . much like this kolam painting in India,
a call for prosperity during harvest season.*

32.

ART IS A VERB

In the past two hundred years or so, art has been treated as something we look at in clean, white, well-lit art galleries and museums. It's been made to seem passive: another tourist attraction to take a picture in front of before you move on.

For most of its entire history, though, art has been *active*: something that does things to or for us, that makes things happen. Holy relics in churches all over the world are said to heal. (There are numerous reliquaries said to contain Christ's Holy Foreskin.) Art has been carried into war, trusted as a shield, used to cast a spell, enlisted as an aid in getting pregnant or preventing pregnancy. The Navajo historically used huge, beautiful, intricately structured sand paintings to ask the gods for assistance, then let them blow away in the wind. The ancient Egyptians painted eyes on their sarcophagi—not for *us* to see, but so the interred person could look out. The paintings inside tombs were meant to be seen only by beings in the afterlife.

Even on the most basic level, art acts upon us all. It sees you across a room and says, "*You.* Come closer. I could change your life."

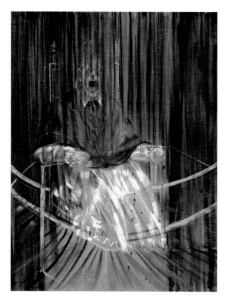

The subject of Francis Bacon's Study after Velázquez's Portrait of Pope Innocent X *(1953) is the pope; the content is far more complicated.*

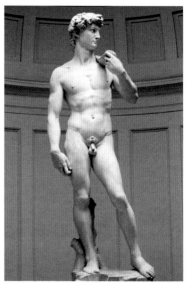

The subject of Michelangelo's David (1501-1504) is a young man. The content is beauty.

33.

LEARN THE DIFFERENCE BETWEEN SUBJECT MATTER AND CONTENT

The subject matter of Francis Bacon's 1953 *Study after Velázquez's Portrait of Pope Innocent X* is a pope, a seated male in a transparent sort of box. That's it. The content, however, is the dark matter within the art that powers it, pushing it out at us, pulling us in. Bacon's content includes rage against authority; an indictment of religion, claustrophobia, hysteria, the madness of civilization; a protest against British strictures on homosexuality; the need for love; the powers of disgust and beauty; and sheer visual force. It also includes Bacon's willingness to go too far, to be a show-off with paint, to depict the depths of his despair and ecstasy. (I'm not even a big Bacon fan and I can appreciate these things.)

The subject matter of Michelangelo's *David* is a standing young man with a sling. The content might be grace, beauty—he was just seventeen; you know what I mean—pensiveness, physical awareness, timelessness, the subtleties of change and changelessness, a form of male beauty and perfection, vulnerability, bravery, thought.

When you look at art, make subject matter the first thing you see—and then stop seeing it. Start seeing *into* the art; find what needs are being expressed or hidden there, what else is behind the narrative. A work of art is a rich estuary of material, personal, public, and aesthetic ideas. Let its water pass through its banks to reach you.

Exercise

Let's make this hard: Try to find the *content* in a painting by Robert Ryman, who made almost-all-white work from the 1950s until his death in 2019. Ask what Ryman's ideas are, what his relationship is to paint, to surface, to internal scale (the size of his brushstrokes), to color. What *is* white to Ryman? Snow? Slush? Something about race? Philosophy? Note the date of the work. Why did he make this painting then? Does it look like other paintings of the time? (Clue: No.) How would it have been different? (Context counts—*a lot*.) Is the stretcher or surface thick, thin, close to the wall? How is this like or unlike other almost monochrome works by Ellsworth Kelly, Barnett Newman, Agnes Martin, or Ad Reinhardt? Is the surface sensual or intellectual? Sloppy, neat, about purity, impurity, something else? Are some parts more important than others? What are the artist's ideas about craft and skill? Is the big question "*What* to paint?" or "*How* to paint?" Do you think this artist likes painting, or is he trying to paint against it? Why should this be in a museum? Why should it *not*? Would you want to live with it? Why?

34.

BE INCONSISTENT

Variety, flexibility, experimentation, diversity—all these are essential in your work. This doesn't mean that every new thing you make should be totally different from what you've done before. That's a sign that you're scared, lazy, or some kind of performative blowhard. (Careful, men.) The real value of inconsistency is that it can bring about what Milan Kundera called "sudden densities"—moments when something appears in your work that gives you an opening, some oddity or mutation that sets you off in a new direction. Variability allows your work to breathe; it helps you to steer clear of tyrannies and find charm in the unfamiliar. Try whatever you want to try: different sizes, tools, materials, subjects, anything. You're not making "product." Don't resist something if you're afraid it's taking you far afield of your usual direction. That's the wild animal in you, feeding. This is how you will evolve new systems of meaning, new combinations and unexpected unions. The way you keep from being caged.

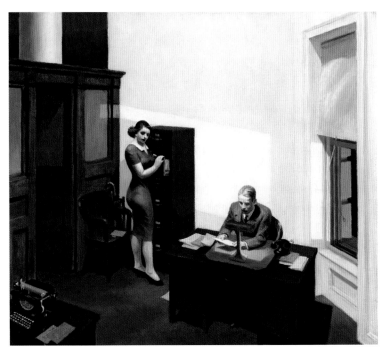

Edward Hopper, Office at Night, *1940*

35.

MAKE STRENGTH OUT OF WEAKNESS

Matisse rarely painted feet. When he did, they're ugly flippers or paws. He mostly hid or extended them beyond the frame. He was exaggerating a weakness, putting his shortcoming right there on the canvas and making it work. Once you notice this, you'll see it throughout his career.

Be Matisse. If you paint awkwardly, make it work *for* you.

Awkwardness can be a locomotive of emotion and formal intelligence. Look at the stodgy blockiness of Edward Hopper's figures—how he sometimes overworks things, how he has a boxy way of painting men and a pervy way of painting women, often breaking perspective just to be able to paint a woman's nipple or some other naughty bit. The war inside Hopper is raging on the surface of his paintings. Or take the transcendentally yearning, ham-handed awkwardness of Marsden Hartley. Even Goya, arguably, could be awkward. You can be, too.

Exercise

BE LIKE KEITH HARING—
MAKE SOMETHING IN A SINGLE SITTING

What's a single sitting? No less than twenty minutes; no more than three hours.

36.

OWN YOUR GUILTY PLEASURES

The days and nights can be long when you're attracted to work that's ignored—or looked down on—by the art world. Hold on to your taste, even when you're embarrassed by it. Those darker sides of your taste can be secret drivers of your art. It might be 1960s psychedelic posters, comic strips, commercial photographs, arcane objects from the distant past, dolls, tarot cards, porn, reality TV, romance novels, whatever. These are forms of ancestor worship. Never renounce them for the sake of others' pieties.

Kitsch, excess, sentimentality—all these are fascinating to study, even with their limitations. I used to be taken by Norman Rockwell, by how his art told you exactly what to feel. I'd marvel at M. C. Escher's endless staircases or the ridiculous frippery of Giovanni Boldini's high-society portraits. A few years ago, I was almost kicked out of the art world for praising the earnest, charismatically vapid art of George W. Bush.

If you *only* like artists like these, you're not yet afraid enough of what you love. If you like them *along with* the greats, though, let yourself enjoy it—and think about why.

37.

MAKE ART FOR NOW, NOT THE FUTURE

Every time I sit down to write, I'm doing it for now. For you, the reader. I'd like my work to survive, but that's not what's driving me. What I want is for it to be *in the conversation*, in the always-changing now. That's why I write every week. My wife, Roberta, says that "writing weekly is like performing on stage." The work we do is written in heat and published at once. That kind of immediacy is focusing, it's energizing, it goads you on. And it keeps us moving. And humble.

If you think that all art should be like High Renaissance painting, or like van Gogh, Eva Hesse, or Basquiat, think again. Human beings are hardwired to crave *change*. The universe is expanding; so are we, and so is art. Which doesn't mean it's getting better, or worse, only that all art was once contemporary art, in conversation with its time. Yours is, too.

Every choice you make—your medium, processes, colors, shapes, and images—should serve not nostalgia, but your visceral present. You are an artist of modern life. That personal, specific urgency is what fuels every successful work of art.

38.

CHANCE IS THE LUCKY BOUNCE OF THE IMAGINATION

P ay Attention Motherfuckers," said Bruce Nauman, and you should. Whenever you're not sure what to do next in your work, momentarily shift your focus and pay attention to whatever songs, sounds, sights, words, news stories, images, or books happen to cross your field of awareness. Use these things! Let them braid in unexpected ways with what you're already doing. Using them gives chance a purpose; using them changes chance's flow. In 1872, after a failed love affair, a woman named Anna Stepanovna Pirogova threw herself under a freight train at the Russian station of Yasenki. The stop happened to be Leo Tolstoy's local station. The next day, he went to the station to attend the autopsy. Five years later he brought us *Anna Karenina*.

Chance is the stunning aurora borealis of creativity—a flickering instantaneity that sweeps across the skies of your work, leaving a trail that can make your work richer and stranger and better.

Alma Thomas, Red Rose Cantata, *1973. An African American
art teacher, Thomas worked for thirty-five years before her retirement,
at seventy, paved the way for a triumphant artistic career.*

Step Four

ENTER
THE
ART WORLD

—

A GUIDE TO THE SNAKE PIT

Alice Neel in her unheated home studio,
photographed by Fred McDarrah, 1979

39.

HAVE COURAGE

Courage can't be measured. Each of us does things in our life and work that require real courage and sacrifice, even if others may never see them. We brave fears, doubts, and demons even when others might not notice. Every good work of art has courage in it somewhere.

Grant your own art that agency. Put your faith in it, let it stave off cynicism and clear a path for you to proceed. Showing your work in public, asking others for guidance, looking for mentors, submitting your art to schools, galleries, grants, residencies—all of this requires tremendous faith. Think of what it took for an artist like Alice Neel to pursue her rough-hewn portraits up in her Harlem apartment when no one else was doing anything like them; for Alex Katz to make his big, flat figurative paintings in the 1950s in the face of the juggernaut of abstraction; for Cy Twombly to deploy erratic scrawls as the carrier of his art. What belief they showed, allowing their art to follow its own intuitive logic.

Courage is a desperate gamble that will place you in the arms of the creative angels.

40.

DON'T DEFINE YOURSELF BY A SINGLE MEDIUM

Don't limit your potential by presenting yourself as just one kind of maker: a potter, printmaker, watercolorist, macraméist, landscape painter, stone carver, steel sculptor, papermaker, glassblower, sketch artist, etcher, graffitist, silk-screenist, collagist, eco-artist, digital or mixed-media artist. *You're an artist.* The insular art world has long looked down on artists who define themselves as medium-specific creators this way—if only because such preemptive titles seem to invite it. But good news: We're living in an electric moment when many artists don't define themselves by medium *at all.* They say multimedia, or they say *all* media, or they just say "artist" and let you figure it out.

I once heard Robert Rauschenberg describe his combine-assemblages as not "painting or sculpture" but "poetry." That's you: a material poet.

41.

NO, YOU DON'T *NEED* GRADUATE SCHOOL

Grad school can be a great idea. It lets you hold off another two years before plunging into the real world. Graduate programs are good hothouses in which to commune with your peers. You'll develop relationships that lead you to new shared languages and allow you to learn things from one another—usually *after* the teachers have gone home.

But grad school is also a risky idea. Unless your parents are paying or you have money, most grad schools are too expensive. Way! I've taught at all the hip schools, and in my experience they're all roughly equal to the so-called not-hip schools. The one difference being that those who go to hot schools get an eighteen-month career bump just out of school. After that, however, the bump disappears and the debt remains.

If you like the idea of grad school, pick a good one at a good price, and go. Work! Get everything you can out of it. Because the real world is right around the corner.

If school doesn't feel like an option, don't let it bother you. Make the world your syllabus: the options are endless, and the price is right.

Jean-Michel Basquiat and Francesco Clemente, photographed by
Patrick McMullan at the launch party for Keith Haring's Pop Shop, 1986

42.

BE A VAMPIRE; FORM A COVEN

No matter how introverted or shy you are, try as often as you can to spend prolonged time with other artists around your age. Artists must commune with their own kind in order to survive. Even if you live in a small town or out in the woods, do everything you can to bond with other artists. In their company, you'll form networks of love and forgiveness that will stop you from being brought to your knees by insecurity, isolation, empty grandiosity, and arrogance. These are the people you will stay up late with, learn from, comfort, fight with, and love; they're the people who'll give you the strength to keep working through the pain. This is how you will change the world—and your art.

Within your gang, your coven, you must protect one another, no matter what. Even if you don't know it, you need one another. At least for now. And this is most important: Always protect the weakest artist in your gang. After all, there might be somebody in the gang who thinks *you're* the one who needs protection.

43.

ACCEPT THAT YOU'LL LIKELY BE POOR

Even though the art world can look like an orgy of glamorous openings, record-setting auction prices, lifestyle features, and avaricious rapaciousness, remember that only 1 percent of 1 percent of 1 percent of all artists get rich from their artwork. You may feel overlooked, underrecognized, and underpaid. There's no getting around it: being poor is *hard*. And probably 95 percent of all artists are just scraping by. Among the artists I've met, though, those who maintain a network of support all live a life that keeps the mind nimble and young, the spirit alive, their art growing and enriching themselves and others who are fortunate enough to see it.

We all struggle—but art lets us plumb even *this* struggle, makes us clear-eyed about matters of class and social inequity. I'm a writer; I've spent much of my life stone broke. Yet I've never regretted the life I've made, happy amid all this art. Nor have I ever met an artist who regretted being an artist, as difficult as the life can be. This is why Isak Dinesen could write, in "Babette's Feast," that "a great artist, Mesdames, is never poor."

44.

DEFINE SUCCESS

But be careful. Artists often try to define success in terms of money, happiness, freedom, "doing what I want," gaining exposure for their work, helping a community.

But . . . if you married a rich person and had lots of money, would you be satisfied with just the money—no recognition, no community, no lasting work? Would you be satisfied if you owned a fast-food chain? (Subway sells a lot of hoagies, but that doesn't make them heroes.)

What about being "happy," you say? Don't be silly! A lot of successful people are unhappy. And a lot of happy people aren't successful. I'm "successful," and I spend a lot of my time confused, terrified, insecure, and foul. (But *always* grateful. Always.) Tough luck! Success and happiness live on opposite sides of the tracks.

You want the truth? The best definition of success is *time—* the time to do your work.

How are you supposed to make time if you don't have money? You will work five days a week for a long time. This might make

you depressed—resentful (*moi*), frustrated (me again), envious (hello). That's the way it is. On Monday, you'll have Friday on your mind. But you're a sneaky, resourceful artist! Soon you'll figure out a way to work only *four* days a week; you'll start to be a little less depressed. More hopeful. After the weekend, you'll be sad to leave it behind—but you'll feel better for the good weekend of work. But your work is a life-and-death matter, so sooner or later you'll scam your way into a job that needs you only *three* days a week. It might be working for a gallery, an artist, a museum; it might be a gig as a teacher, an art handler, a bookkeeper, a proofreader, whatever. A three-day-a-week job means four days off—four days to make your own art.

See? You've achieved the first measure of success: time. Now get to work. Or give up your dreams and muster out. There's the door.

45.

ART AND THERAPY

We're all damaged—some more than others, some traumatically. My mother committed suicide by jumping out of a window when I was ten; there was no funeral; my family never spoke of her again. No one ever told me it was suicide, so I learned to figure things out by picking up codes and feedback from the outside world. I grew antennae. Everyone in our Chicago suburb started treating me differently. My new stepmother beat me with a belt. I found myself with two new brothers, one my own age: I became a twin. I never did schoolwork again. I left home the night I graduated from high school—at the bottom of my class. I don't think of this as trauma. It's just my life. It's a miracle any of us makes it through.

What about therapy? Therapy can be great for artists. So can tai chi, tarot, fashion, sports, walks, God, massages, dancing, and so on. Whatever your personal story, find a practice that eases your mind, gives you perspective, and allows you to work. These are spirit guides in other guises. If you work very hard and try to be very honest with yourself, your art might tell you almost everything you need to know about yourself.

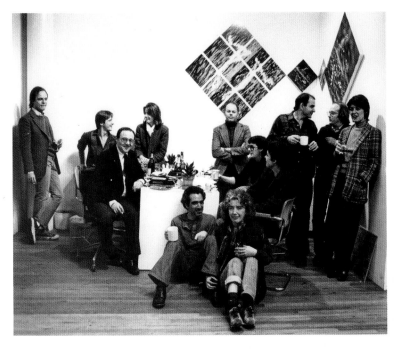

A birthday gathering for gallery director Douglas Baxter at the Paula Cooper Gallery, New York, c. 1980. From left: Julian Lethbridge, Baxter, Max Gordon, Julie Graham, Peter Campus, Elizabeth Murray, Mark Lancaster, Ellie Griffin Jack, Jennifer Bartlett (whose artwork is on the wall), Joel Shapiro, Michael Hurson, and Cooper.

46.

IT TAKES ONLY A FEW PEOPLE
TO MAKE A CAREER

Exactly how many? Let's count.

Dealers? You need only one—someone who believes in you, supports you emotionally, pays you promptly, and doesn't play too many mind games; who'll be honest with you about your crappy or great art; who does as much as possible to spread the word about your work and tries to make you some money from it, too. This dealer doesn't have to be in New York.

Collectors? You need only five or six collectors who will buy your work from time to time and over the years, who really *get* what you're up to, who are willing to go through the ups and downs, who don't say, "Make it like *this*." Each of these six collectors might talk to six other collectors about your work. Or not. Six collectors should be enough for you to make enough money to have enough time to make your work.

Critics? It would be nice to have two or even three critics who seem to get what you're doing. It would be best if these critics were of your generation, not geezers like me.

Curators? It would be nice to have one or two curators of your generation or a little older who would put you in shows from time to time.

That's it! Twelve people. Surely your crappy art can fake out twelve stupid people! I've seen it done with just one or two! The late, visionary gallerists Colin de Land (of American Fine Arts) and Hudson (of Feature Gallery) often exhibited artists that only *they* had seen, artists who'd never shown anywhere else.

Here's the one condition: You *have to put yourself out there.* No matter how hard it is for you. You have to show up, apply to everything, go to openings even if it's just to stand around feeling inadequate. (The secret is, 80 percent of us are doing exactly this at most openings—and we often end up meeting other interesting artists there, commiserating, sharing thoughts about the work.) Talk to the other wallflowers! Most galleries, curators, collectors, and critics learn about artists *through other artists.* Pay attention to what the galleries are showing; figure out which ones might like what you do. Forget about the mega-galleries; look for places and people who might see your work as an opportunity. Don't overprice your work when you're getting started, either—that only makes it harder for anyone to take a chance on you. (Jeff Koons priced his early work at less than fabrication cost.)

I can't sugarcoat this next part: Some people are better connected than others. They get to twelve supporters faster. The art world is full of these privileged people. It is unfair and unjust. It's still a problem for women and artists of color especially, not to mention artists over forty. The road is rougher for these artists. This needs to be changed. By all of us.

47.

LEARN TO WRITE ABOUT YOUR WORK

When it comes to writing artist statements: Keep it simple, stupid.

Don't make writing a big deal. You already know how to write! You've been writing things your whole life—even if they're just Post-it notes. Don't use art jargon; reject cant; write in your own voice, the way you talk. Keep your statements direct, clear, to the point. Don't fall into the trap of opposing two big abstract concepts, like "nature" and "culture." Avoid words like *interrogate, reconceptualize, commodity culture, liminal space, haptic.* You don't want to sound like you're just revving the old engines of postmodernist rhetoric. (Much of this lingo has lost value in the art world today, and besides, lingo has nothing to do with your real artistic goals.)

On the other hand, you want to do more than just say to the viewer, "*You* tell me what it is." When it comes to your work, you're the best authority there is. Instead of quoting the theories of Foucault, Deleuze, or Derrida, come up with your own. All art is a theory about what art can be. (Some people claim

to hate theory; they say they have no theory. I say, "That's your theory, you idiot!")

Important things are hard to write about. That's the way it is. Say what you mean, even if it seems humble or humdrum. If it sounds too pretentious, don't say it. If you're not sure, wait and see—if you're being unbearable, your peers will let you know.

Exercise

Write a simple one-hundred-word statement about your work. Give it to someone who doesn't know your work at all and ask them to tell you vaguely what they think your work looks like.

48.

THERE'S NO SUCH THING AS "FEAR OF SUCCESS"

I'm always surprised when I meet young artists who insist that they're afraid of success—that it might corrupt their principles, or ruin their work, make them lose sight of their "real goals," or whatever. I don't buy it. Saying you're wary of success is just a cover story for insecurity, fear of rejection, terror of being revealed as a sham, and the rest of the boring jam you spread on yourself in order to keep doing the easy thing, which is to *not work*. It's much easier to *not* work than it is to work. Don't take the easy way out. Or do—and quit. Just stop pretending you'd work if only you weren't so darn afraid of becoming successful. It's bull.

Jaune Quick-to-See Smith, The Red Mean: Self-Portrait, *1992*

Step Five

SURVIVE

THE

ART WORLD

———

PSYCHIC STRATEGIES FOR
DEALING WITH THE UGLINESS
(INSIDE AND OUT)

49.

YOU'VE GOT TO WANT IT

Sometimes I think this is Rule One. Even someone as seemingly inept and unpromising as Jackson Pollock essentially *willed himself* to newness. The artist Julian Lethbridge has formulated an efficient description of wanting it: "To be an artist," he says, "it helps to be persistent, obstinate, and determined. These are the things that enable an artist *not* to banish but to outwit the doubts that will come from many directions." He means that this drive, this need, is what will help you face situational and emotional headwinds—and get back to whatever flatworms you were cutting up before your latest obstacle. Wanting it is what allows us to place ourselves again in our aesthetic lattices, feeling for the ideas, inspirations, dreamscapes, and other thermal updrafts that will flow through the fear and doubt. Persistence, determination, and obstinacy give you energy. They'll get you through hell, taking you from *wanting* it to *doing* it to *living* it.

50.

MAKE AN ENEMY OF ENVY

Envy looks at others but blinds you.

It will eat you alive as an artist; you'll live in its service, always on the edge of a funk, dwelling on past slights, always seeing what *other* people have, scanning for other artists who are mentioned in some story instead of you. Envy distracts the mind, leaving less room for development and, most important, for honest self-criticism. It crowds your imagination with the lives of others, rather than what you need to be doing in your own work. From the fortress of envy, everything that doesn't happen to you is blamed on something or someone else.

Don't let jealousy define you, make you sour, bitter, unloving, or mean. So all those other "bad artists" are getting shows and you're not. So they're getting the articles, money, and love! So they went to better schools, married someone rich, are better-looking, have thinner ankles, are more social, have better connections. It's tough. We all do the best we can. But "Poor me" can't make your work better, and you're out of the game if you don't show up. So grow a backbone and get back to work.

51.

DEADLINES FROM HEAVEN

Deadlines are sent from heaven via hell. When you have to finish a certain work by a certain time, the pressure can sicken you, make you feel rotten. I haven't *not* been queasy with deadlines since I became a weekly critic. But deadlines force you to muster the mettle to work.

Remember, your work is entirely voluntary—so procrastination is a self-harming habit. Deadlines are great for forcing the issue, concentrating your work, prompting unexpected epiphanies, and keeping you living under the psychological volcano. The solution? Vow never to miss a deadline. If you don't have a deadline, set one for yourself. Many famous artists make their own one-day deadlines: Luc Tuymans, Josephine Halvorson, Lynette Yiadom-Boakye, Henry Taylor, and Frank Auerbach do, as did On Kawara, Keith Haring, and Pablo Picasso. It's a trick that helps you keep the work open, unresolved and developing.

Meet your deadlines.

Put down this book, if you have to! If I'm holding you up, I'm the enemy.

Get it done. It'll change your life.

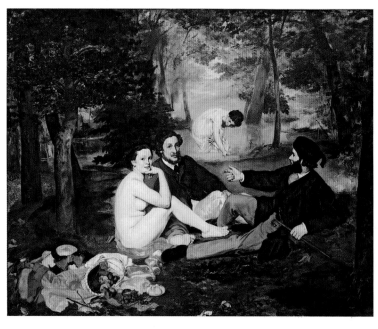

Manet's Le déjeuner sur l'herbe, *1863: Inconceivably vulgar?*

52.

LEARN TO DEAL WITH REJECTION

I tell artists to grow elephant skin, because they're going to need it. Criticism happens, even to the masters. After a precocious debut, Claude Monet was rejected repeatedly by the Paris Salon. The work of Édouard Manet was said to display "inconceivable vulgarity." Manet didn't want to exhibit with Paul Cézanne, whose work *he* thought was vulgar. A contemporary critic wrote, "Does Mr. Degas know *nothing* about drawing?" In 1956, "after careful consideration," the Museum of Modern Art rejected a shoe drawing that Andy Warhol had offered to the museum. When Willem de Kooning retained figurative elements in his art, Jackson Pollock snapped at him, "You're betraying it!"

See? We critics are wrong every day. Curator Henry Geldzahler wrote, "A review is just you or me having an opinion." He added that most reviewers lack the ability "to see further than we can." When you get a critical review, it may be that the critic couldn't see far enough.

But don't ignore bad reviews. Instead, keep your rejection letters, bad reviews, slights, oversights, and the rest. Paste them

on your wall. They are goads, things for you to prove wrong. Don't get taken down by them; they don't define you.

Much trickier: Accept that any piece of criticism might have a grain of truth to it—that something in your work allowed this critic to lower the boom. Maybe it's that you're ahead of your time or the critic can't see this type of work. Or maybe the piece that caught the critic's eye was an experiment they didn't know how to process. Or maybe you haven't yet found a way to make your work speak to the people you're trying to reach. That's on you. Take it in; don't blow it out of proportion; then get back to work.

I always tell anyone criticizing me, "You could be right." It has a nice double edge; sometimes the victim never feels a thing.

53.

HOW TO RECOVER FROM CRITICAL INJURIES

Let's say you've shown some work and it's been panned—or, worse yet, ignored. What do you do? Jim Lewis, the novelist and art critic, has strong feelings on this subject. "If people dismiss your work," he told me in an e-mail, "strive to make them hate it. If no one hates it, it might not be art. This is not because offending people is inherently valuable, nor even because new things always invite misunderstanding and disapprobation. Both of those are clichés. But any true gesture put out into the world is bound to please some and displease others. Don't make your art go down that easy. Many of the artists I love best are widely despised (sometimes by each other). Don't be afraid of this. It's inevitable. Samuel Johnson said, 'Fame is a shuttlecock. . . . To keep it up, it must be struck at both ends.' Often you can learn more from the boos than from the applause, particularly if you're brave enough to really think about them. Those qualities in your work that bother people the most are often precisely the ones that should be cultivated, pushed so far out on the axis of vice that they come around to be virtues."

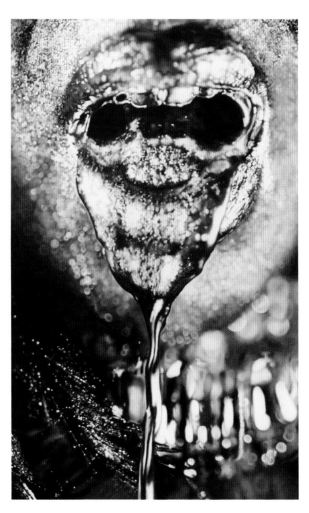

Marilyn Minter, Drizzle (Wangechi Mutu), *2010*

54.

OVERNIGHT IS OVERRATED

I know why people yearn for sudden success. I want all artists to be successful. But—as sexy as a thirty-month career is—I want to speak up loudly on behalf of the thirty-*year* career. I want you to have whatever you want, but most of all I want you to be able to *do* what you want, until the day you die. I want to die working, frustrated, trying to fix something, trying a hundred ideas, until something clicks into place and I get that moment's high. Art gives up its secrets very slowly. Thirty months isn't enough; it takes a lifetime.

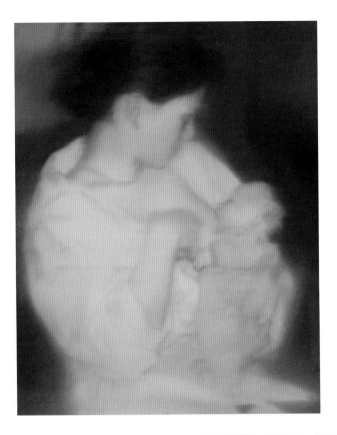

In work like S. with Child *(1995), Gerhard Richter displays a deep engagement with his family (shown here in a photograph by Thomas Struth).*

55.

HAVING A FAMILY IS FINE

There's an unwritten rule—especially for women in the art world—that having children is "bad for your career." This is idiotic. Or growing more so by the day. Probably 90 percent of all artists have had children. These artists have mostly been men, and it wasn't bad for their careers. Of course, for centuries women were tasked almost exclusively with domesticity and child-rearing, excluded from schools and academies, not even allowed to draw the nude from life, let alone apprentice to or learn from other artists. Tragically, this means that for thousands of years, art has been telling us far less than half the story. In many parts of the world this is changing. My hope is that mothers—as well as other women artists, artists of color, all those often excluded from the main stage—will soon be able to achieve careers as major as those of the decades of undeserving mediocre men before them who used white male privilege as a golden staircase.

Having children is not "bad" for your career. It does usually mean having less time or money or space. Dividing your attention among work, family, and career, while negotiating the dangerous straits of other people's biases, is no walk in the park. But legions of women artists do this now; legions more will in the future, as these archaic prejudices erode.

The artist Laurel Nakadate points out that being a parent is already very much like being an artist. It means always lugging things around, living in chaos, doing things that are mysterious or impossible or scary. As with art, children can drive you crazy all day, make you yearn for some peace and quiet. Then in a single second, at any point, you are redeemed with a moment of intense, transformative love. "Being a mother-artist leaves no casual time. Mother-artists learn to use both hands, stay up all night comforting humans who think the world is ending, become experts at cleaning up blood and vomit and shit in darkness, and then, they go to work with the civilians. They put on clothes, they take phone calls, give talks, plan schedules, explain themselves, they go into professional meetings having survived emotional and physical upheaval. All this makes them better artists." It's also clarifying: "When my son was born, it became quite clear to me who still took me seriously as an artist, and who assumed that, because a human came out through my vagina, I could no longer use my brain."

But the biggest reward may be that artists' kids tend to have amazingly diverse, wonderful lives. "My son has been to every museum in New York City," Nakadate says, "and believes

that making things is what everyone does. He likes to paint in the middle of the night, he has a studio practice. . . . He talks about reflections on surfaces and what shape feelings become." When she wrote this, her son was only two years old! Can I get an amen?

Hilma af Klint, The Ten Largest, No. 7: Adulthood, *1907*

Step Six

ATTAIN

GALACTIC

BRAIN

———

COSMIC EPIGRAMS FROM
BETTER HEADS AND MINE

Michelangelo, The Creation of Adam, *1508-1512*

56.

"ART IS A LIE THAT TELLS THE TRUTH."
—PABLO PICASSO

Picasso's quip expresses something complicated that I feel deeply. Art is a lie that changes how we see the world, the way we remember, categorize, experience, and feel about what we see. Oscar Wilde mused that London's famous fog gained its character only *after* artists invented it. Many have said that Raymond Chandler invented early-twentieth-century Los Angeles in our imaginations. Francis Ford Coppola cast our vision of both the Mafia and the Vietnam War. The reason we envision God creating Adam the way we do is, at least in part, because Michelangelo painted it that way.

Perhaps the world's four major holy books—the Torah, the Bible, the Quran, and the Vedas—are so powerful simply because they're beautifully written, so much so that people worship their characters and are willing to live, die, and kill for them. As D. H. Lawrence said, "Never trust the artist. Trust the tale."

57.

"ARTISTS DO NOT OWN
THE MEANING OF THEIR WORK."
—ROBERTA SMITH

R emember: Anyone may experience your art—any art—in any way that works for them. You may say your work is about diaspora, but others might call it a reflection on climate change or a nature study. "This is something you want," Roberta elaborates. "This means your work is *alive*, that it has more than just *you* in it. . . . If you're lucky, it will remain alive long after you're gone, changing and growing as more and more people come into contact with it."

That's what happens when you put your work out into the world. People will talk.

Let them. (You couldn't stop them if you tried.)

58.

ART DOESN'T PROGRESS

I n school, in history and biography, in the ways we learn about the world, we're all conditioned to think that the history of art is a story of forward progress. One thing leading in traceable ways to another. That's flat wrong. Art changes, of course. But it happens in stages, in shifts, granularly, bit by bit, in lurches and breaks and false starts and great leaps. All art comes from other art, and often the throughlines and arcs of influence can be revelatory. Knowing that Willem de Kooning emerged almost bodily out of Arshile Gorky ("I come from 36 Union Square," he said, referring to Gorky's studio), who grew out of Picasso, who grew out of African sculpture and Cézanne, we see their work in a new way. But not everything connects: Brancusi isn't a direct progression from van Eyck, who has nothing to do with Ethiopian manuscript painters, whose work doesn't draw on Neolithic sculpture or the stone axes made by

Neanderthals. Art is the simultaneous coexistence of change and stability. It is less an arrow than a plasma cloud, always with us, never the same.

Exercise

MAKE THAT TRAIN

Once a year, make a colored drawing of a train with twelve cars, with each car representing an artist you somehow feel connected to. Make it beautiful if you want, but you don't have to; the cars can just be rectangles on wheels with artists' names on the sides. Maybe you want to name the tracks, background, clouds, passing landscape, or buildings. *Don't draw the engine.* It's engines all the way down.

After several years of doing this, make one very large colored drawing of *all* the visuals on your personal train bound for glory. It will be a streetcar of your desires.

59.

WHAT YOU DON'T LIKE IS
AS IMPORTANT AS WHAT YOU DO LIKE

Painting is dead," people are always declaring. "The novel is dead." "Photography is dead." "History is dead." Don't be an art world undertaker! Nothing is dead! Don't say, "I hate figurative painting." You never know when your taste might prove you wrong.

Instead, when you come across a piece of art you don't like, ask yourself: *What would I like about this work were I the kind of person that liked it?* Make a checklist of its qualities; try to spot at least two good qualities along with the bad. What is the work's approach to color, structure, space, and style? Is it craftsmanlike or just craftsy? Is it simplistic? Muddy in a bad way? Are the edges mishandled? Are the artist's ideas of line, subject, surface, and scale derivative? Is it too male? Too obviously funny? Telling you too much? If you find it "didactic," define exactly what that means to you—and what a work of art should be instead. At the very least, this should give you a working list of your own artistic values. It'll make your artist statement much sharper, too.

Georgia O'Keeffe with her painting Red with Yellow *(from her* Pelvis *series), photographed by Tony Vaccaro, Albuquerque, New Mexico, 1960*

60.

YOU MUST PRIZE RADICAL VULNERABILITY

What's that? It's following your work into the darkest or most dangerous corners of your psyche, revealing things about yourself that you don't want to reveal but that your work requires you to, and allowing yourself the potential of disappointment. We all contradict ourselves. We contain multitudes. You must be willing to fail flamboyantly, to do things that seem silly or stupid, even if they might put you in the crosshairs of harsh judgment.

Consider the lifelong derision the American genius Georgia O'Keeffe faced for giving free rein to her vision. In the early twentieth century, O'Keeffe was one of maybe a dozen people on earth creating completely abstract images—yet the male critics of the era dismissed her as "a painter of female genital organs." O'Keeffe never gave in or stopped portraying her own enigmatic world. She said only that she considered it a shame to be viewed as "silly" or "girly." "I'm one of the few artists, maybe the only one today, who is willing to talk about my work as pretty."

Channel your inner O'Keeffe.

61.

YOU ARE ALWAYS LEARNING

At the end of each day, you know something you didn't know at the beginning. We're all learning on the job. This is true even when the thing you've learned is that you knew less than you thought. Whatever you're creating makes you more than you were before you made it.

62.

BE DELUSIONAL

At three a.m., demons speak to all of us. I am old, and they still speak to me every night. And every day.

They tell you that you're not good enough, you didn't go to the right schools, you're stupid, you don't know how to draw, you don't have enough money, you aren't original; that what you do doesn't matter, and who cares, and you don't even know art history, and can't schmooze, and have a bad neck. They tell you that you're faking it, that other people see through you, that you're lazy, that you don't know what you're doing, and that you're just doing this to get attention or money.

I have one solution to turn away these demons: After beating yourself up for half an hour or so, stop and say out loud, "Yeah, but I'm a fucking genius."

You are, too. You know the rules. They're your tools.

Now use them to go change the world.

Get to work!

Lynette Yiadom-Boakye, Willow Strip, *2017*

63.

OH, AND ONCE A YEAR, GO DANCING

Why? Because dance is as old as art—and one day you won't be able to dance anymore.

ACKNOWLEDGMENTS

I spent the time before I became a writer on a thirty-five-year battlefield of my own making, paralyzed by demons who preached defeat. Thank you to all those whose energies, visions, drive, laughter, placating mercies, and fierce dedication allowed me to migrate out of my aloneness. First among these, always, is Roberta Smith, for me the greatest critic of the late twentieth and early twenty-first centuries, who ignited my life and fire, who wouldn't stand for excuses, who made me just get on with it, who finds a skeleton key to every work of art, whose revelations around art, and faithful aurora of body and mind, empowered me to try to give those things back to her and pass them along to the world. Her love song of a life lived in art and criticism became my imperium of absolute beauty, and a place within which to work.

Thank you to David Wallace-Wells, the editor of a lifetime, whose hand has shaped nearly all my work for the past six years and allowed me to go to places in my mind and writing I could never have reached without him. ("Yes and . . .") To all those at *New York* magazine, thank you for changing my life. Whenever my writing turned me into a ghost ship, unable to navigate, a visit to the NYM offices has always left me replenished with love. To Adam Moss, who hired me after I said no twice, thinking, "I'm not good enough for this job," only to call back and say, "No, wait, I *have* to have this job!" To

Jody Quon, whose visual spirit and lightning genius guided and drove me, and who with Stella Blackmon and Katherine Barner helped find many of the spectacular images for this book. To my first editor at *New York*, Chris Bonanos, who "broke" me with his kind hand and gentle heart and helped my writing make sense. Thank you to David Haskell, the best choice alive to step into Adam Moss's shoes, and to Pam Wasserstein, whose joy, intensity, and commitment to always trying to get better, to always trying to make this work, made me feel seen and appreciated. There are too many others to mention: just know that all of you at *New York* have given me far more than I could ever repay in the Dunkin' Donuts and Gristedes cookies I bring to the office.

My weekly writing life began and came to fruition at *The Village Voice*—another job I took in full awareness that I wasn't yet up to the task. Thank you to Vince Aletti for having the faith and patience to choose me when I should not yet have been chosen, essentially saving my life, and making me into a weekly critic.

One thousand hours of conversation with the artist Carroll Dunham has led me to ways of thinking I could not have imagined; without ever throwing shadows, his dominant mind, ferocious lucidity, and perverse logic and laughter have unwoven and rewoven my mind. The artist Laurie Simmons showed what it meant to adopt orphans of the mind and spirit, those (like me) almost lost to love and work, and her roving artist's mind always made rendezvous with her unexpected and sweet. Roberta and I never wanted kids; these two gave us two dazzling godchildren—thank goodness. Lena Dunham and Cyrus Dunham bridged so much mystical interior distance with us and with the world at large; both are shaping their times with their art and honesty, as surely as they shaped our capacity for love.

While simultaneously inspiring me, spurring me on, and leaving me breathless, Julian Lethbridge and Anne Bass have blessed me with friendship

and an atmosphere of creativity that comforts and compels me, that makes me want to show up. I had begun to take down my inner tent when these two shined on me; what they've helped make happen for me has bestowed on me the best physical and metaphysical space for writing that I could ever have.

Like anyone who is creative, I come from studying, admiring, and imitating the work of others, wanting to embody their qualities, their energies and outward kindnesses, most of all the willingness to speak up, to place oneself in the crosshairs, to risk not being liked. Thank you to Francesco Bonami, Barry Holden, Jay Gorney, Eric Fischl, Anne-Marie Russell, Jeanne Greenberg Rohatyn, Susan Schulson, Ilona Granet, Emilio Cruz, Àngels Ribé, Anne Doran, Freya Hansell, and Richard Martin (the first person who ever asked me to write something). Thank you to Laura Hoptman (executive director of the Drawing Center, and still way unsung), Massimiliano Gioni (from whom I got so many ideas in the early 2000s), Scott Rothkopf (ditto, but in the past ten years), Jonathan Burnham (who led me to my amazing literary agent, Chris Calhoun); to Howard Halle, Matthew Weinstein (for the ideas and your work), Matthew Ritchie (ditto), Geoff Young, Donna De Salvo, Ann Philbin, Anne Pasternak, Ali Subotnick, Collier Schorr, Stuart Regan, Barbara Gladstone (who actually showed my own fledgling work for a minute in the 1970s), Deborah Solomon and Dr. Kent Sepkowitz (who helped Roberta and me in our darkest hours of medical need); to Jasper Johns, Dan Cameron, Peter Plagens, Martha Schwendener, Jason Farago, Will Heinrich, Ken Johnson, Linda Norden, and Dave Hickey (who calls me from the desert out of the blue, saying things that leave me puzzled but starstruck with his genius); to Dodie Kazanjian, Calvin Tompkins (whose books on art and artists parted the curtains for me and many others), Gavin Brown (whose fire for art burns as strong and articulate as that of anyone I've ever met), and Clarissa Dalrymple (whose equally bright fire burns with more charisma than I've ever seen, and in whose Wooster Street loft I met almost the whole art world

in the 1990s, when I was still driving a truck); to Kenny Schachter (whose auction/art world writing is the best out there). To my smartest, funniest lifelong personal friend, Dr. Lawrence Higgins (who correctly, *empirically*, diagnosed all three cases of my Lyme disease—and, yes, I'm never leaving the pavement again). And to Dr. Paul Sabbatini and the magnificent saints and bodhisattvas at Memorial Sloan-Kettering.

Thank you to the butterfly and diving bell of criticism, Peter Schjeldahl, for our daily phone calls to commiserate on art and more art, criticism and shop-talk, our fears and difficulties with writing, our idiot-male ideas and observations, and for understanding that we can be best friends and lifelines without seeing each other more than once a year.

Thank you to Steve Martin and Anne Stringfield, Cindy Sherman, Austin Kleon, David Chang, Roz Chast, Jill Soloway, Kim Gordon, Amy Sedaris, and Tracey Emin.

In 2018, after years of being approached by editors and publishers, all of them suggesting the one thing a weekly critic really can't do—a book of entirely new work—I heard from Calvert Morgan at Riverhead, who reached into a place I had thought gone, and said, "I know how to make a book with you." Thank you to him and to the rest of the Riverhead team: Geoff Kloske, Kate Stark, Anna Jardine, Catalina Trigo, Grace Han, Helen Yentus, Claire Vaccaro, Lucia Bernard, Shailyn Tavella, and the wonderful Jynne Dilling Martin—who is the first person I've ever listened to when she told me not to "go rogue on social media."

ILLUSTRATION CREDITS